SPIRIT
TRANQUIL
LANDSCAPES

PHOTOGRAPHS BY

CHANG CHIH-HUEI

張志輝的

靈・靜　山水

「眼前這片風景不知有幾百萬隻眼睛已經看過，但對我來說卻像是大地流露出來的第一個微笑。」

——卡謬

"No matter how many million eyes have taken it in before me, to me the landscape before me is like the first smile to break out of the earth."

——Camus

主流之外—張志輝的心中風景

文 ： 阮 義 忠

在我所敎過的學生當中，張志輝的攝影方向和其他人是很不一樣的；他幾乎很少拍人，我也從沒看過他拍報導方面的作品。我大部份的學生或多或少都認同我的攝影風格，而在人文攝影這條路上，默默行進。

我也沒有鼓勵張志輝走報導攝影的路子，因爲上課時他給我看的照片絕大部份是風景作品。他的專情及毅力越來越強，而他所拍攝的那些本省非常偏遠的深山景色，更深刻的表現出他對大自然的嚮往及禮讚。

和報導攝影相比，我對風景攝影是外行多了。不過由於我有十多年的時間，在本省東南西北各個偏僻角落四處行走，對這片土地罕爲人知的壯麗景色，也略窺一二。張志輝的這些風景作品，倒是很容易就喚起我一些難忘的回憶。這位樂天知足得有時令人覺得過份天眞的年輕人，的的確確用他的方式，用他的看法，用他的感受，將台灣的大自然——那些還沒有被破壞，還沒有被污染的可愛大地，顯影給我們看。

家住彰化的張志輝，要專程來台北上我的課是很辛苦的。每個禮拜他都要來回折騰兩趟，並且要利用時間拍照交作業，這非得要有一股傻勁不可；而這股傻勁也充分表現在他所選擇的攝影方向上。毫無疑問的，近年來傳播媒體一直提供比較大的空間給報導攝影，而美術性及觀念性的攝影最近也漸漸多了一些園地。相形之下，風景攝影就變得非常冷門，而且常被歸屬於業餘的沙龍攝影圈。然而張志輝並不在意這些，他全心致力於風景表現也有四年光景了。他這麼表示：

「眞正吸引我一直有股勁兒往山裏跑的原因很單純，主要的是四季的變化。雖然台灣的四季比不上歐美國家來得分明，但只要仔細觀察，變化依然很多，而且每跑了一些地方，仍常常去那些地方。其實說穿了就是把那些地方當成朋友，而也眞正認識了許多朋友，因此我常去看"朋友"。以前常自己一個人，騎著摩托車，帶著簡單的炊具、背著相機、到處走走拍

拍；有時在山上會感受到一個人於大自然的渺小，一個人於人群的孤獨。也或許是因為情感方面不順心如意，那種獨自一個人的孤獨感受，就無心地隱藏在作品裏面，透過影像表現出來。」

張志輝在中部小鎮生活工作，無法像在大都市一樣很方便的接觸各種資訊，但是他旺盛的求知慾往往克服了種種不便，而使他獲得一些精神上的養份。下面這段話完全反映了他自學的收穫：

「記得有位好友曾經告訴我，紐約現代美術館有個展覽，把攝影分成了兩類：一個是"窗子"、一個是"鏡子"；如此一分，似乎就很容易區分影像的型態了。就以此為例，剛一頭栽進黑白這個領域時，我想我所拍的風景都是屬於"窗子"，而目前所拍的大部份傾向於"鏡子"。有窗子也有鏡子，更貼切地說，應該是：窗子外面的鏡子——用心的感受，用心的體會，用心的直覺，來表現親身歷其中的大自然……風景攝影。放鬆心情才能讓"心"和大自然的變化一起律動。」

張志輝對攝影的熱情甚至使他在彰化市成立了「阿爾攝影藝廊」，替他的幾位攝影朋友開了幾檔個展，最近因財力的問題而暫時結束了藝廊。而他這幾年所累積下來、數量可觀的風景攝影作品，現在有機會舉行個展並出版攝影集，對他及讀者來說，都有特別的意義。

張志輝默默地走著這條冷門的路，現在看起來反而是件好事，當大家都朝同一個方向前進的時候，孤獨的張志輝反而顯得突出。他是一個很單純的人，單純得有點傻氣，但是這樣的人往往比較能夠堅持一些事情。希望他的堅持隨著日積月累會更有所成。不過我想單純的張志輝倒不會去管那麼多，他有他自己獨特的看法。本文就以他的一段話當結束：

「總之，大自然充滿無窮的魅力一直吸引著我。心隨境轉，境隨心轉都是很值得表現的題材；只有真心，真正的喜歡，才會執著、才會固執；對風景如此，人也如此。」

BEYOND THE MAINSTREAM: CHANG CHIH-HUEI AND HIS INNER LANDSCAPE

TEXT BY JUAN I-JONG

Among all my studnts, Chang Chih-huei has taken quite a different photographic direction from the others. He seldom aims his camera at people and I have never seen him doing any reportage. Most of my students more or less identify with my photographic style and proceed quietly along the road of humanism.

I never encouraged Chih-huei to do reportage since most of the work he showed me in class was of landscape. I could see that he was becoming more engaged in and tenacious of photographing landscape of secluded mountains in Taiwan. The work reveals strongly his longing and admiration for the nature.

Where landscape photography is concerned, I am absolutely a layman. However, as I had travelled extensively to the distant corners of Taiwan during a period of more than ten years, I knew as well some magnificent spots unknown to most people. Chih-huei's landscape recalls immediately some of my memories.

Chih-huei is a very contented and optimistic person, sometimes to the extent of being innocent. With his own perception and vision, this young photographer has exposed in prints the loveliness of Taiwan's nature that has not yet been spoiled and polluted. Attending my photographic class in Taipei was an arduous trip for Chih-huei, whose hometown was in Changhua. Besides travelling to and fro Changhua and Taipei once a week, he had to find time to work on his assigment for the class as well. It demanded a great steadfastness to stick to such a schedule. The same steadfastness was also fully demonstrated in his choice of photographic direction. In recent years, reportage photography has obviously been given more exposure in mass media. Artistic and conceptual photography have also been gaining ground in the field. In comparison, landscape photography is less popular and often placed in the category of amateurish salon photography. None of this bothered Chih-huei. It has been four years now since he started to fully devote himself to photographing landscape. He says: "The reason that I'm never tired of going to the mountains was very simple. I am fascinated by the seasonal changes in the mountains. Though the changes are not so obvious as they are in Europe, a lot of variations can be found under careful observation. There are places where I visit again and again because I consider them my friends. And I actually made many friends there. I like to visit my "friends" whenever possible. I used to travel alone in the mountains on my motorcycle, carrying light cookers and my cameras, taking photographs along the way. At times I would feel so insignificant in the face of nature and the solitude of being among crowds. My relationship with the opposite sex, which was not always satisfactory, probably had to

do with this feeling of loneliness that I unconsciously projected in my imgaes."

Living and working in a little town of central Taiwan, Chih-huei found it harder for him to get access to all sorts of information than those who live in the city. But his strong will to learn has overcome various inconveniences and helped nourish him spiritually. The following paragraph totally reflected what he has harvested from self-learning:

"A good friend of mine once told me about an exhibition at Museum of Modern Art in New York. The exhibition devided photography in two categories: the window and the mirror, which has made it easy for us to tell the different types of images. Take myself for example. When I first picked up black and white photography, the landscape that I photographed fit in the category of 'the window', and my recent work is more of 'the mirror'. To be more precisely, it is actually 'a mirror outside the window'. To present the nature that you have experienced with your heart's eyes and intuition. That's what landscape photography is all about. Your have to relax yourself and let your 'heart' beat with the rhythm of nature's changes."

Again Chih-huei's great passion for photography prompted the establishment of "Arles Photo Gallery" where he gave several exhibitions for some friends who love photography. Lately the gallery was temporarily closed because of financial difficulties . However, over the years Chih-huei has accumulated a large amount of landscape work, which will soon be shown in personal exhibitions as well as published in a book . It is especially meaningful for Chih-huei and the readers as well.

Chih-huei has been quietly working in the field of landscape photography, which is less popular. Now it seems a bless in disguise for him. When most people are moving in the same direction, Chih-huei's solitary silhouette stands out in the crowd for choosing a different path. He is a very simple person. So simple that people may think he is silly. Nevertheless, people like him can be more persistent in certain things. Hopefully, his persistence will pay off in the long run. But I don't think Chih-huei, as simple as he is, will care too much about this. He has his unique way of seeing things. Finally I would like to quote his words as an ending paragraph:

"In a word, the endless charm of mother nature has always attracted me. Whether the mood changes with the environment or vice versa, both are worthwhile subject matters. Only when you genuinely like something, will you stick to it, hold on to it. This applies to landscape as well as to people."

風 景 的 靈 魂

任誰目睹了張志輝那一幀幀階調豐富，靈光閃現的黑白山水照片，難免要興起〝但願彼時我
也能在那裡…〞的嘆息。於微熹晨光輕喚的林間作甦醒後的第一次深呼吸，讓薄霧的幽冥沿
鼻腔鑽進胸臆，復從嘴巴吞吐進大氣中。於鬚根凍結的薄冰溶化前，在刺骨的水瀑間漱洗，
憑任肌膚表層的疙瘩傳導神經的顫動，從脊椎直上腦門及至靈魂深處。當日頭爬上樹梢的針
葉尖，攀高於羣峯環伺的山頭，遠眺波光粼粼的海畔，頭頂呼嘯而過的魑魅流雲。傾刻間，
所有塵寰俗世的紛紛擾擾，鬱鬱的情緒和哀愁，以致存在困境和靈魂底桎梏，都將在陽光燦
然的照拂下，在大自然振奮的樂章中銷解、煙滅。

「 精神四飛揚；如出天地間 」

「 思出宇宙外；曠然在寥廓 」

這正是我們面對張志輝的作品所獲得的整體印象，以及可能達致的奇幻的效果。倘若在觀照
的同時，有那麼一刻，你試著脫去靈魂的罩衫，回復存在的根本精神狀態，走入照片底層的
形上世界。

有別於沙龍照片和以操弄影像為能事的當代攝影作品，浸淫在〝純攝影〞領域近二十個
年頭的張志輝，一則不能滿足於沙龍膚淺的形式唯美，同時對現代攝影主流的聳動、露骨，
和意識形態販賣，也不敢恭維。他的黑白山水作品，既非機械式的再現如實的自然，也不是
以自我為本的心象寫真。作為俯仰天地的存在主體，他走進大自然，懷抱近於宗教的敬虔，
耐住性子，用心靈的眼睛等待。鑒於志輝對大自然的熱愛，和幾近瘋魔的執著，也因為他一
絲不苟的攝影態度與純熟的暗房工藝技術，使我們見識到每一幀靈光閃現的完美影像──大
自然母親對孩子的慷慨饋贈。

馮君藍　1999.01.19　於陽明山台灣神學院

SOUL OF THE LANDSCAPE

Anyone encountering the richly layered, shimmering black and white landscape photography in Chang Chihui's *Spirit Tranquil Landscapes* photography exhibition might need to stop and catch themselves from gasping aloud and exclaiming, "I wish I had been standing there at that moment." The woods, bathed in the faint light of dawn, take their first breath upon awakening, passing a stream of misty air through your nostrils and filling your chest, then expelling it out into the atmosphere. Before the light frost on your sideburns melts, cleansing the body in a stinging cold waterfall as goose bumps transmit shivers from the surface of the skin along the entire nervous system, straight from the spine to the brain and deep into the soul. When the sun climbs over the leaves on the trees, beyond the towering withered trees , standing atop the lookout, embraced by countless peeks and surveying the glistening coast below, a ghostly cloud whisks overhead... In this instant, the trouble, afflictions, and sadness of the world, together with the plights of existence and cages of the soul, dissolve into nothingness in the joyous symphony of nature.

> *The spirit soars high, like a bolt out of this world*
> *Thought ascends beyond the cosmos, expanding into infinity*

This is my impression of Chang Chihui's art, and the magical effect it can have on one—as if, in the moment of observation, you try to remove the veil from your soul, returning to the basic state of existence—entering a metaphysical world beneath the photograph.

Unlike salon photography and contemporary photography often marked by manipulation of imagery, Chang Chihui, immersed in the realm of "pure photography" for nearly 20 years, cannot be satisfied by the shallow formal aesthetics of the salon. Nor is he at all impressed with the visceral punch and ideological merchandising of the contemporary mainstream. Rather, Chang's black and white landscape photography is neither a straightforward mechanical representation of nature, nor a self-referential portrait of the mind. As an existential subject surveying the vast world, he enters nature, embracing religious piety, holding back his impulsive nature to wait for a look through the eye of the soul. Chang Chihui's passion for nature, bordering on wild obsession, at the same time invests his darkroom technique with a marked meticulousness and dexterity, so that in each shimmering image of perfection we see Mother Earth's benevolent gifts to her children

FUNG CHUN-LAN
19 *January* 1999, *Taiwan Seminary*

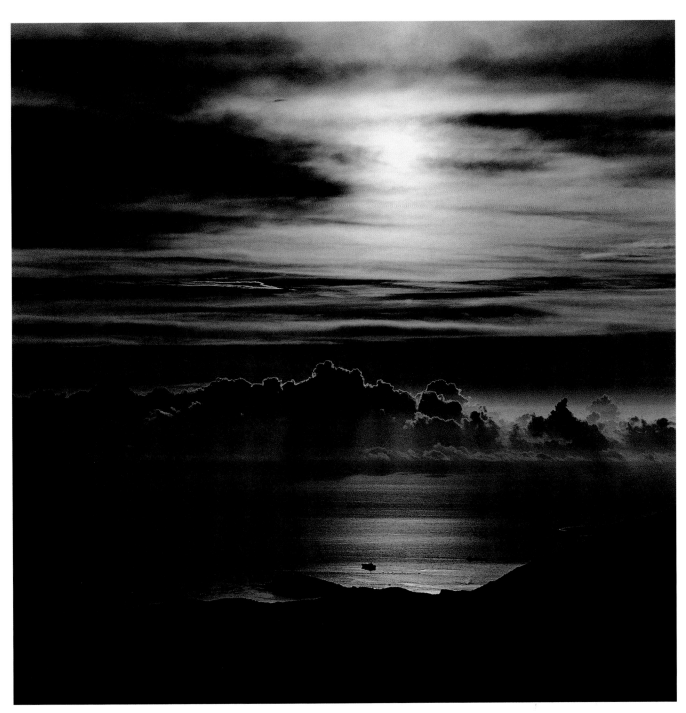

Mt. Datuen, Taipei, 1996　台北・大屯山

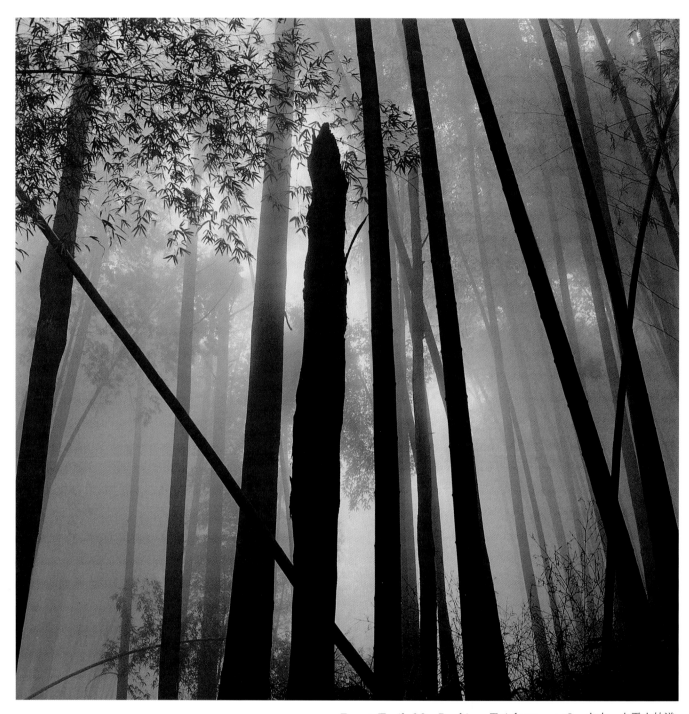

Forest Trail, Mt. Dashiue, Taichung, 1998　台中・大雪山林道

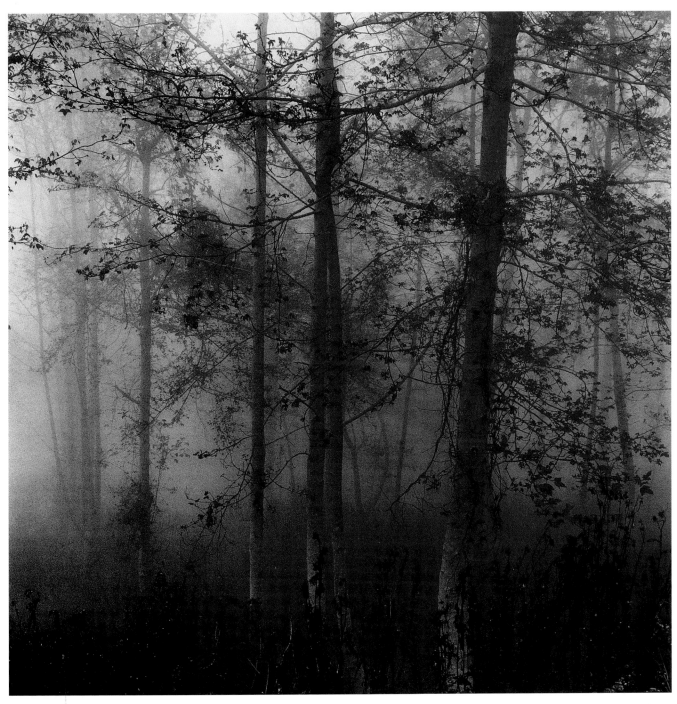

Fengshulin Farm, Nantou, 1995　南投・仁愛鄉・楓樹林農場

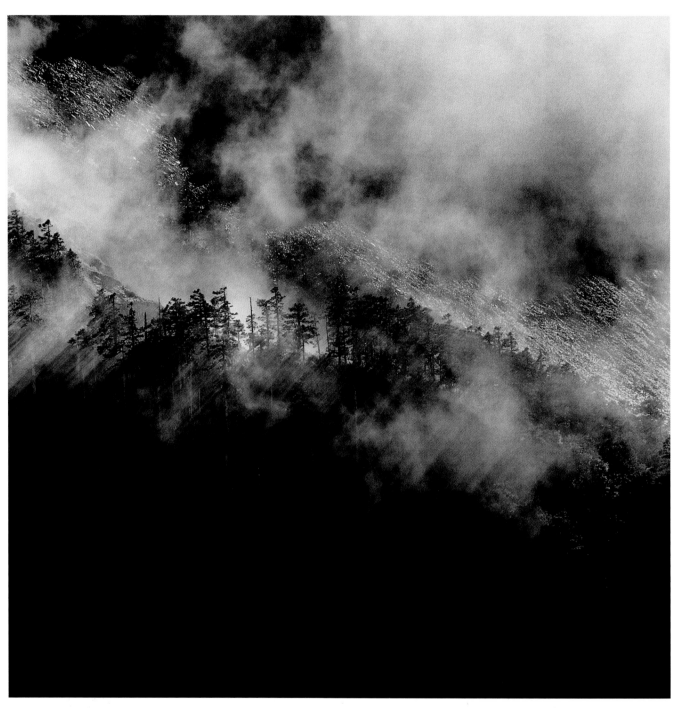

Mt. Hehuan, 1994 合歡山

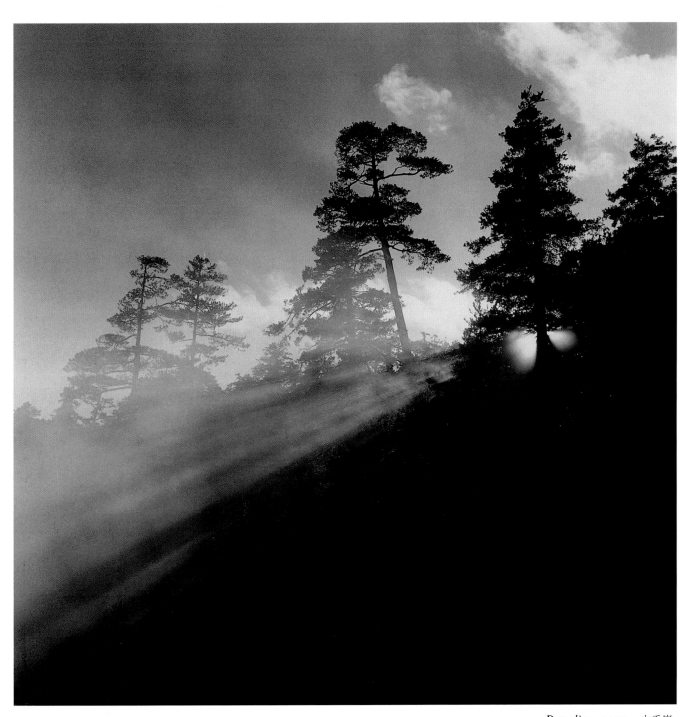

Dayuling, 1997　大禹嶺

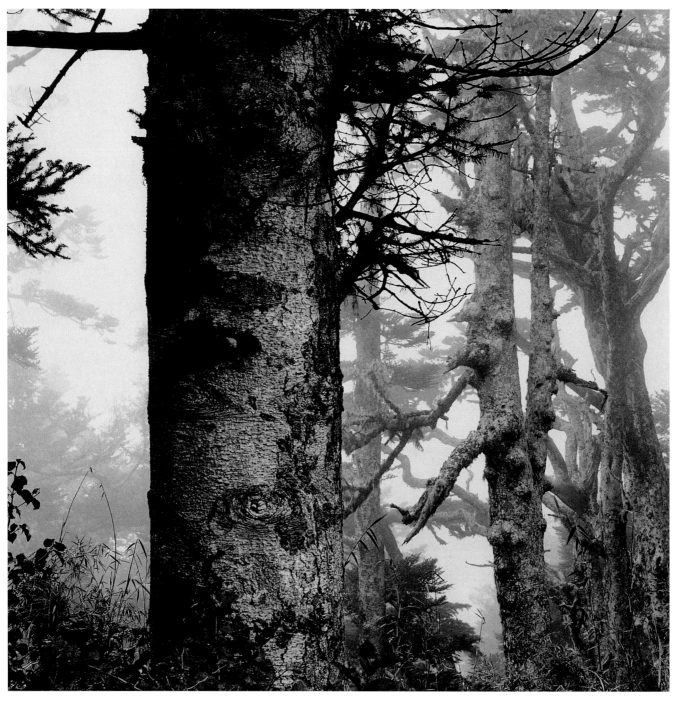

Mt. Hehuan, 1995　合歡山

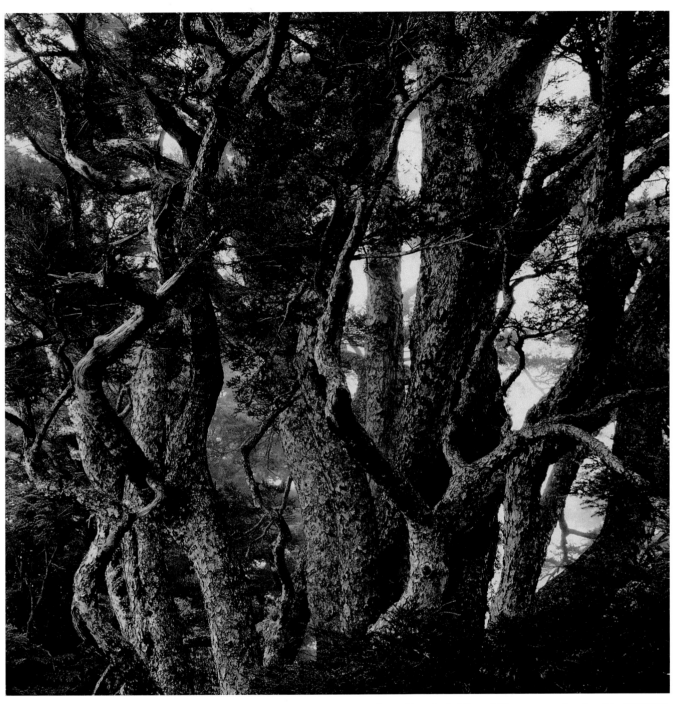

Near Yuanfeng, Provincial Road No. 14, 1996　台14甲・鳶峰附近

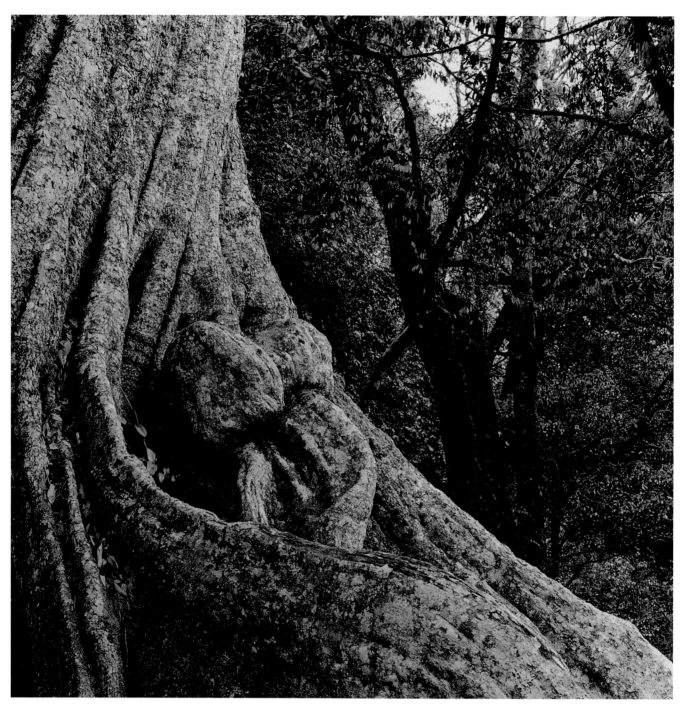

Sacred Tree, Shueili, Nantou, 1999　南投・水里永興神木

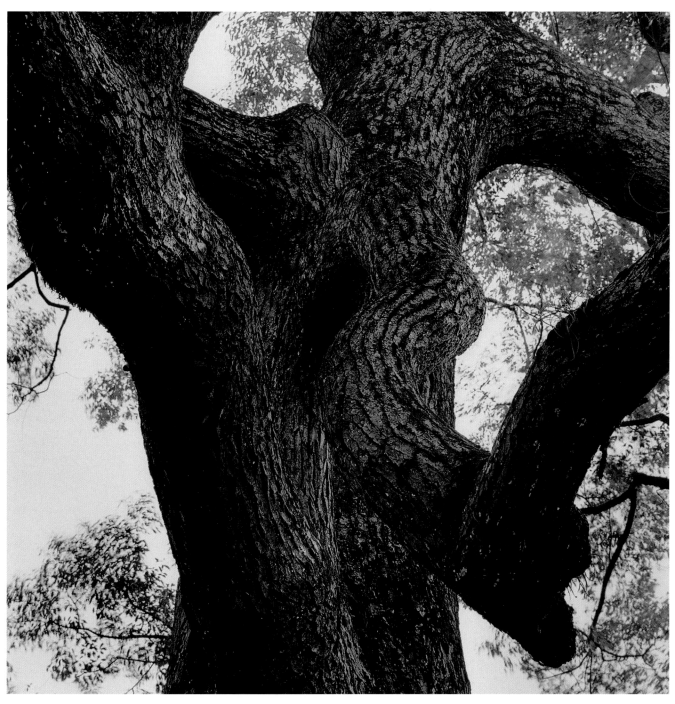

Northern Mt. Dungyan, Nantou, 1995　南投・北東眼山

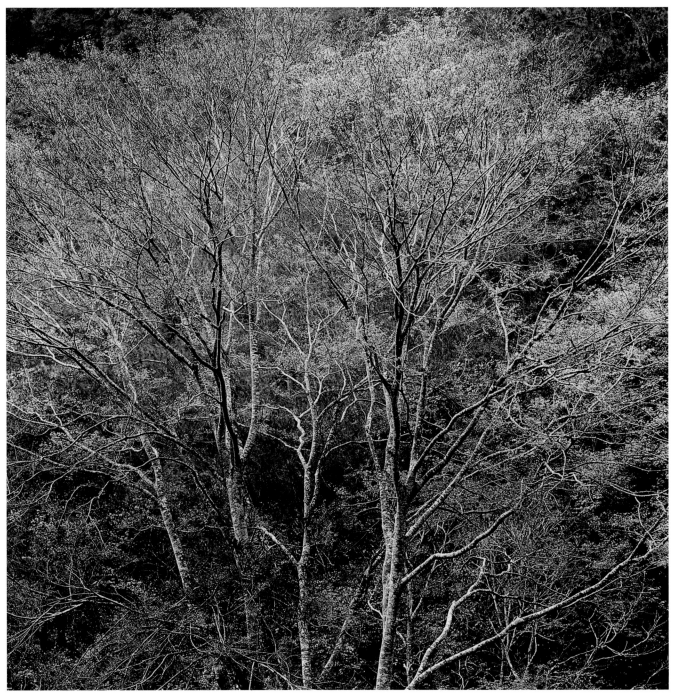

Dream Valley, Nantou, 1993　南投・仁愛鄉・夢谷

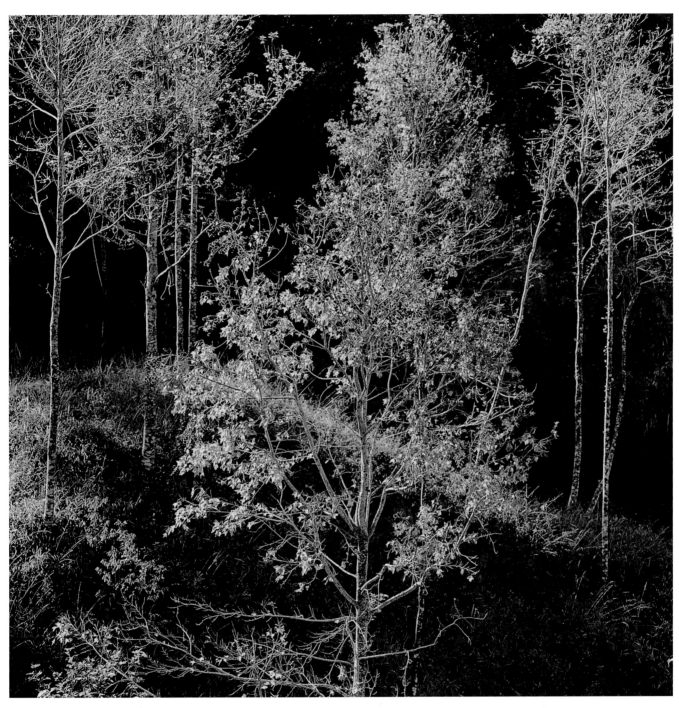

Fengshulin Farm Nantou, 1997　南投・仁愛鄉・楓樹林農場

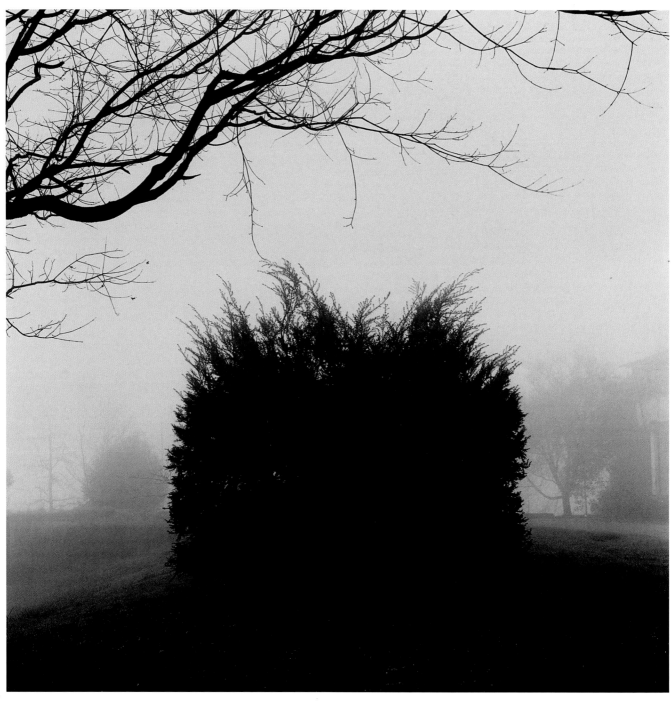

Taiwan University Farm, Provincial Road No. 14, 1997　台14甲・台大農場

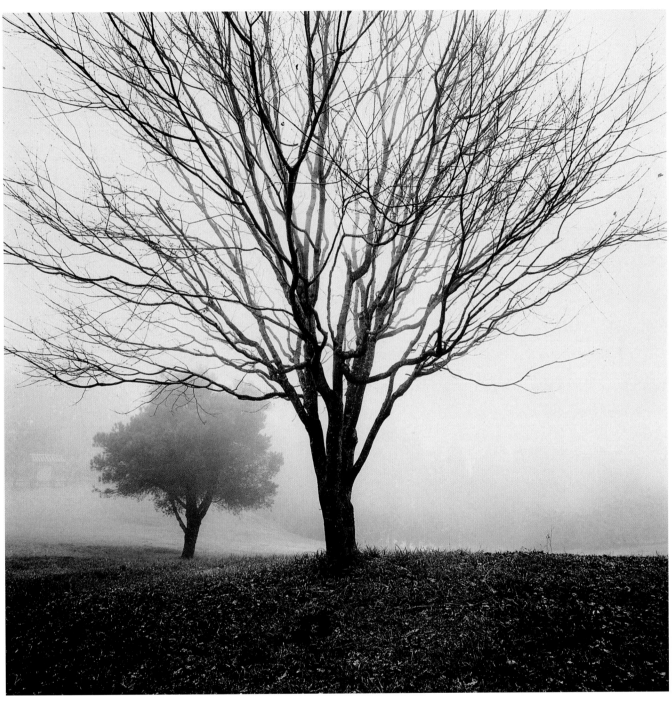

Taiwan University Farm, Provincial Road No. 14, 1997　台14甲・台大農場

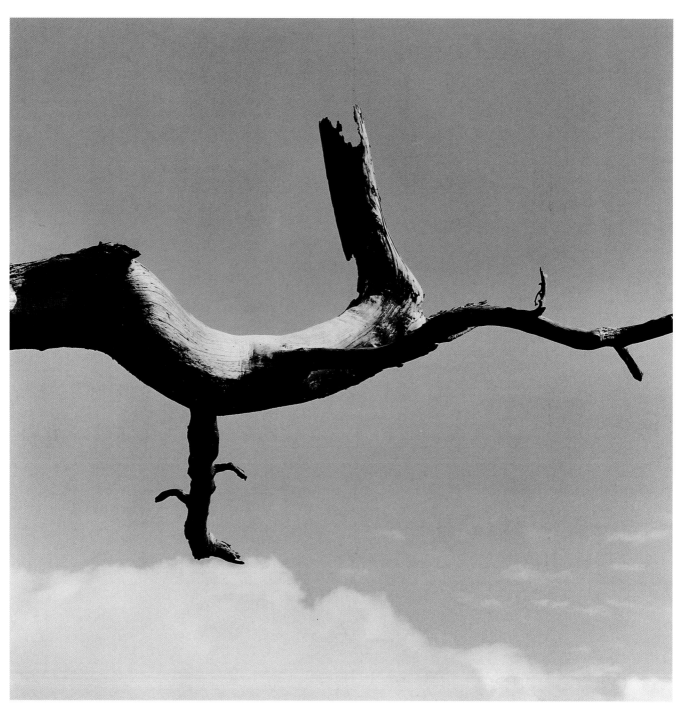

Tianchr, Mt. Fushou, 1997　福壽山・天池

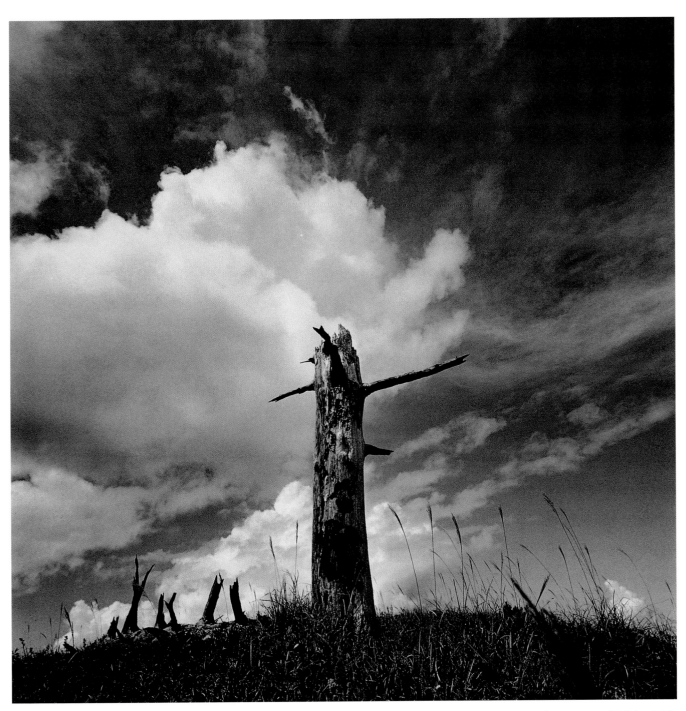

Tianchr, Mt. Fushou, 1995　福壽山·天池

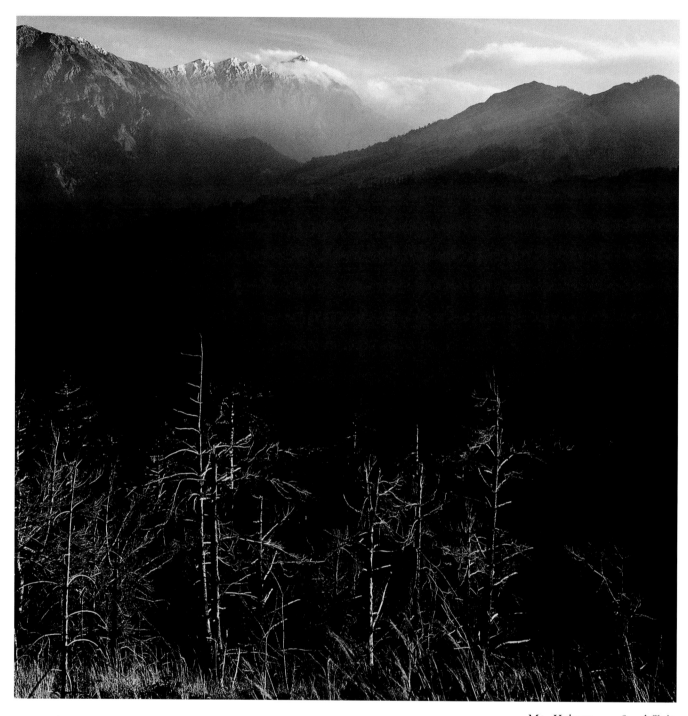

Mt. Hehuan, 1996　合歡山

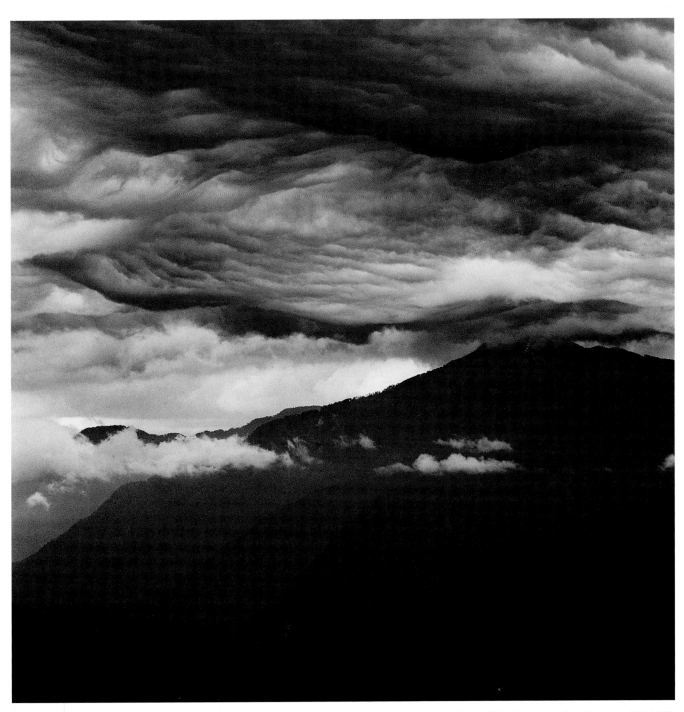

Forest Trail, Mt. Dashiue, Taichung, 1998　台中・大雪山林道

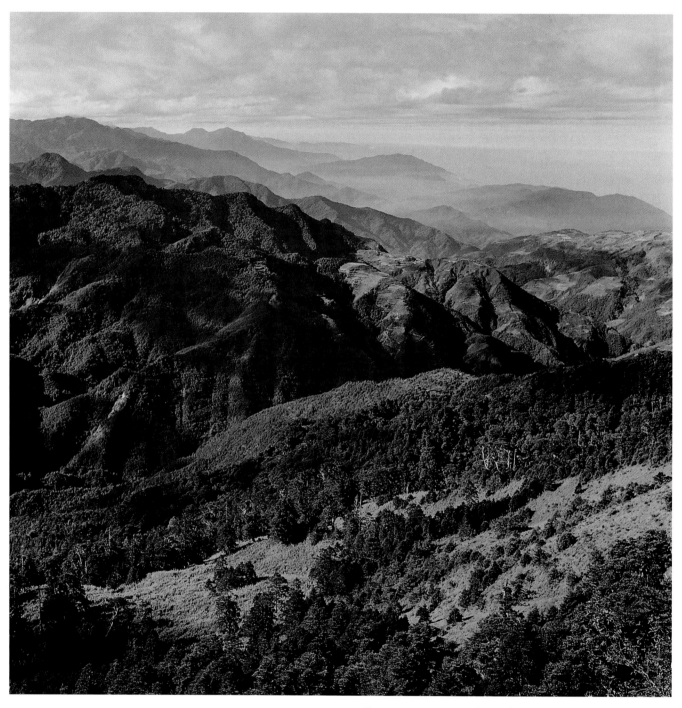

Kuenyang, Provincial Road No. 14, 1997　台14甲・昆陽

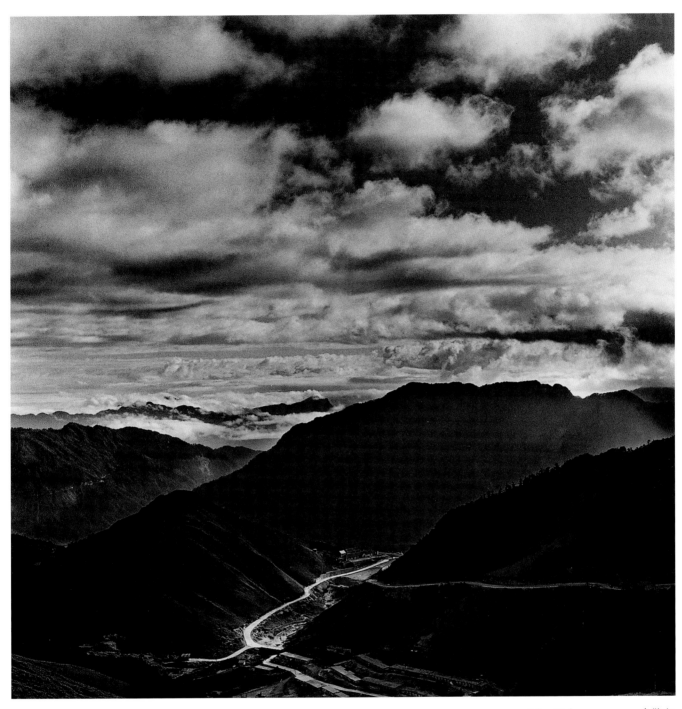

Mt. Hehuan, 1993 合歡山

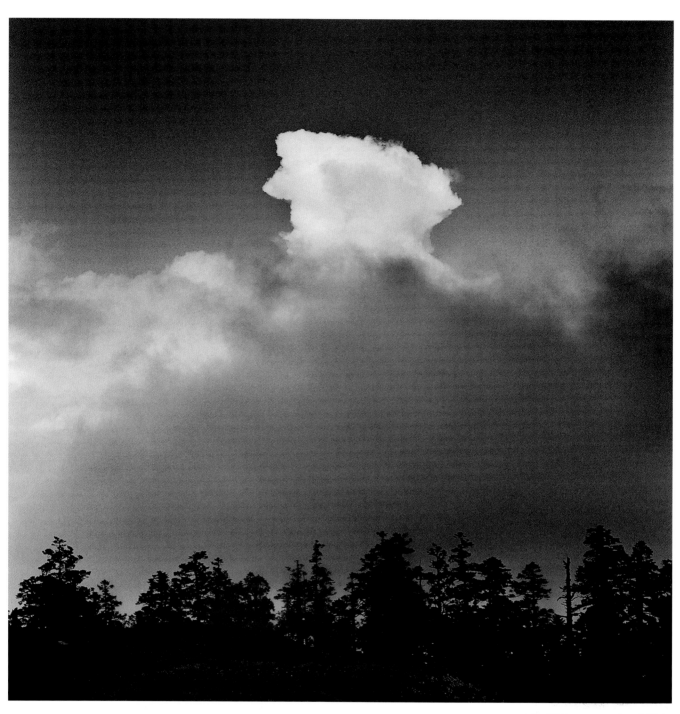

Mt. Hehuan, 1996　合歡山

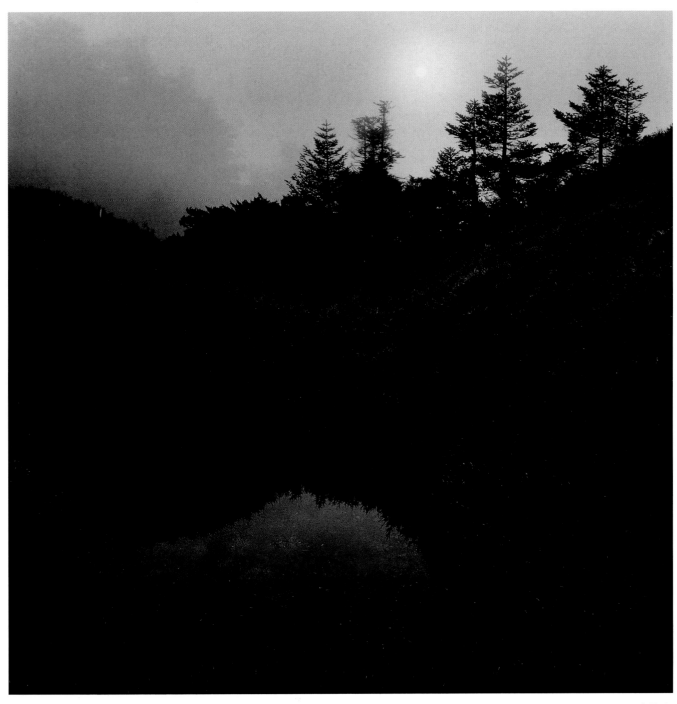

Mt. Hehuan, 1996　合歡山

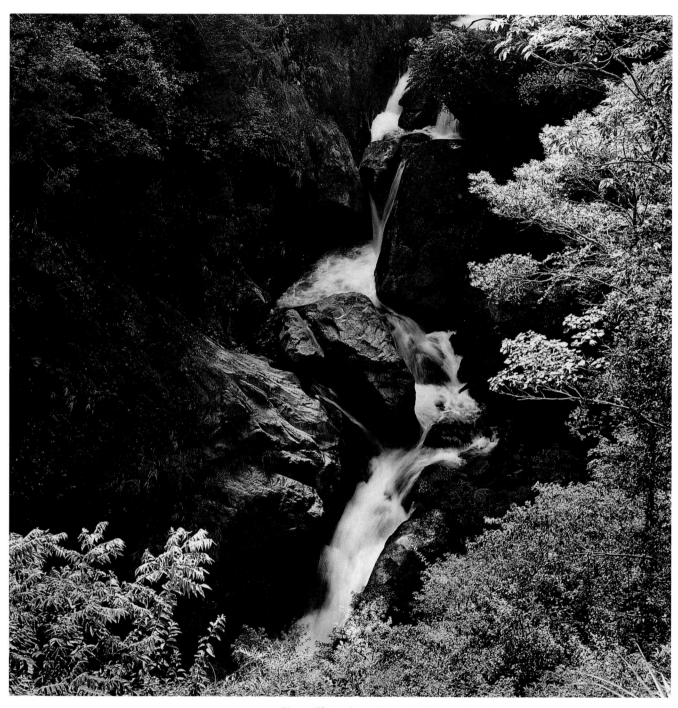

Near Chingshan, Central Cross-Island Highway, 1997　中橫・青山附近

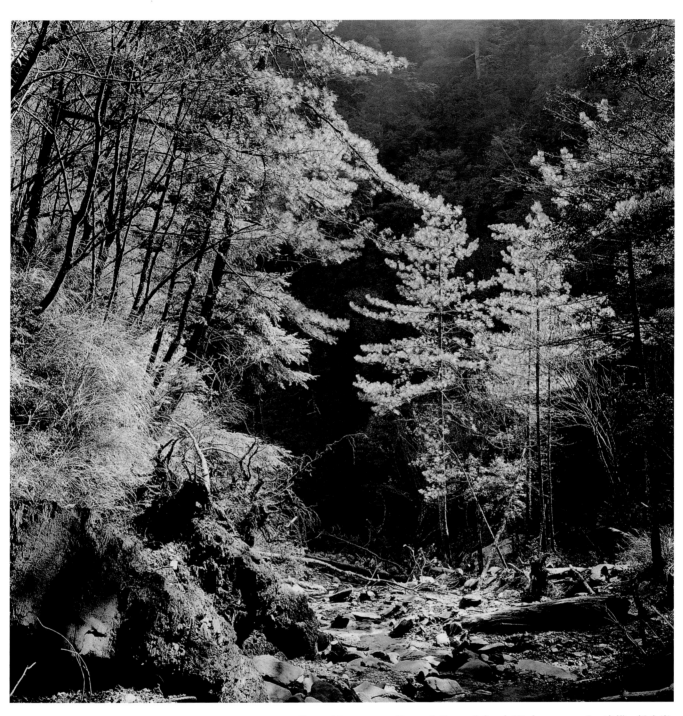

Sungchiuangang, Central Cross-Island Highway, 1996　中橫・松泉崗

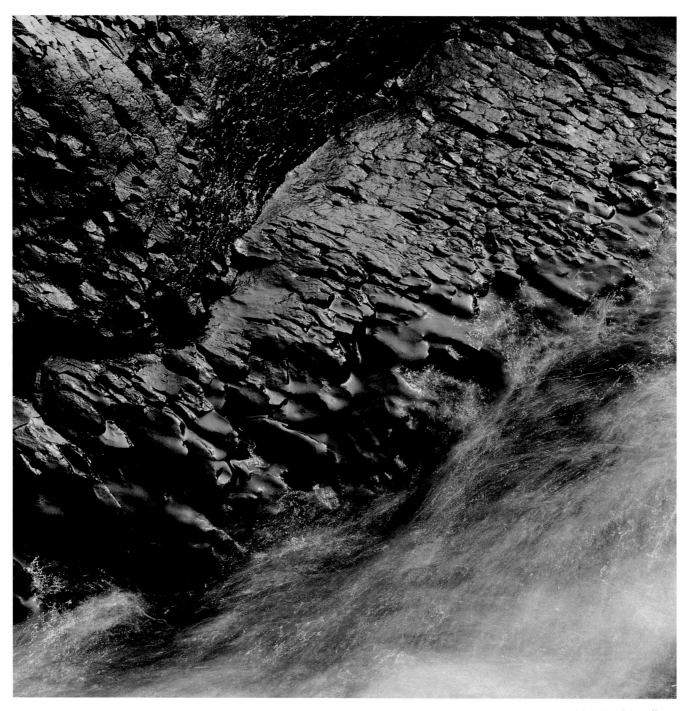

Dream Valley, Nantou, 1994　南投・仁愛鄉・夢谷

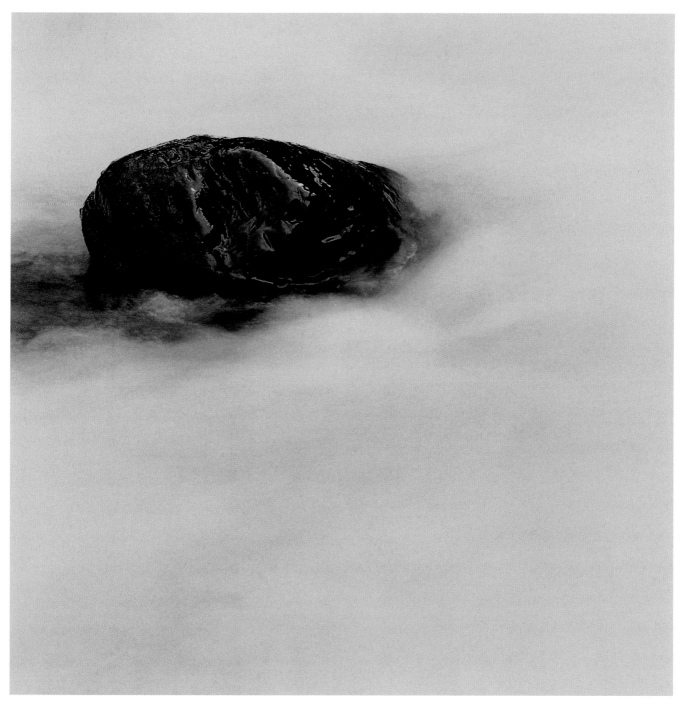

Dream Valley, Nantou, 1994　南投・仁愛鄉・夢谷

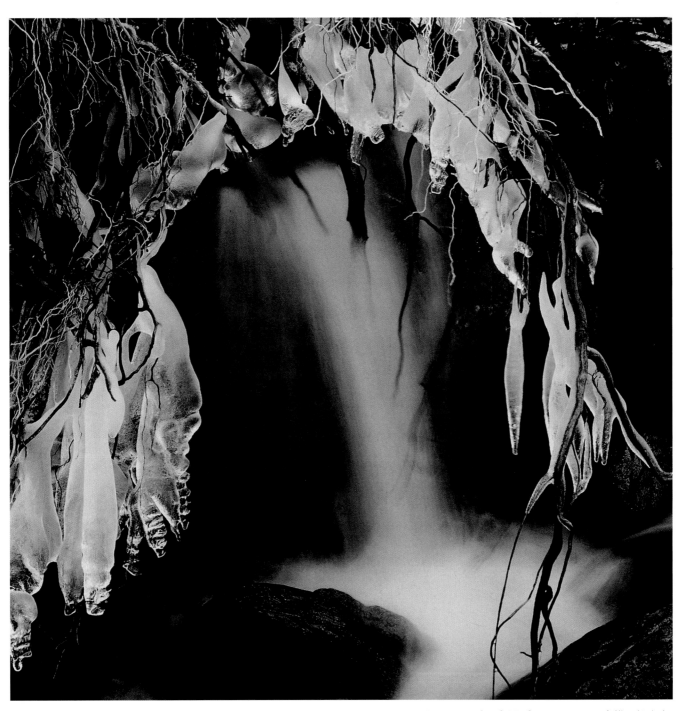

Sungchiuangang, Central Cross-Island Highway, 1995　中橫・松泉崗

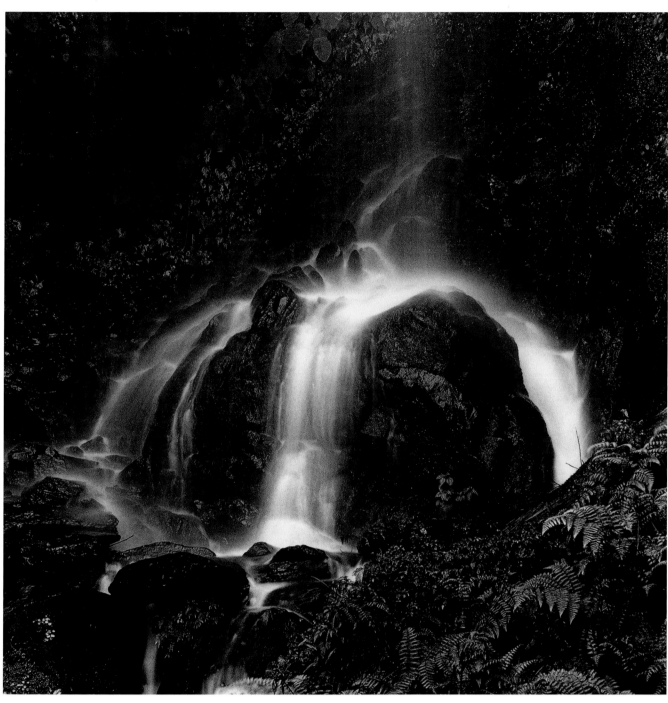

North Cross-Island Highway, 1996 北橫

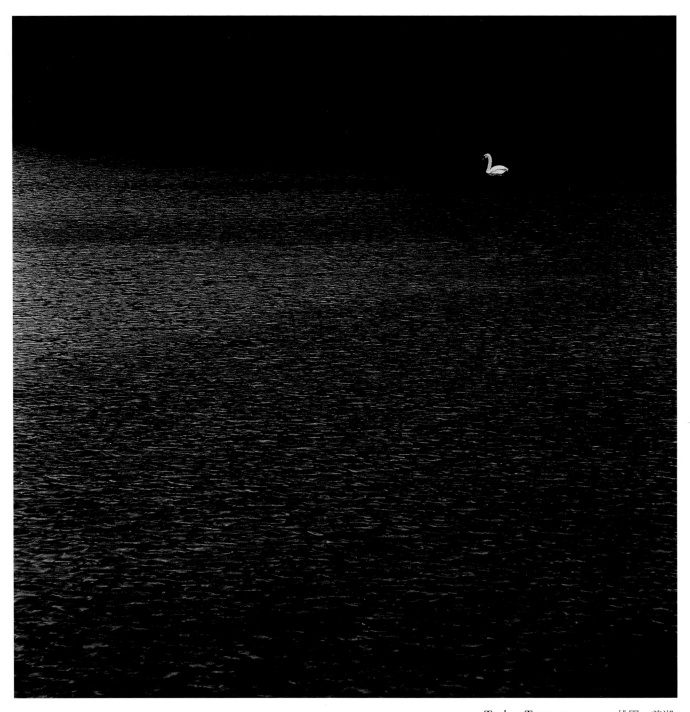

Tszhu, Taoyuan, 1994　桃園・慈湖

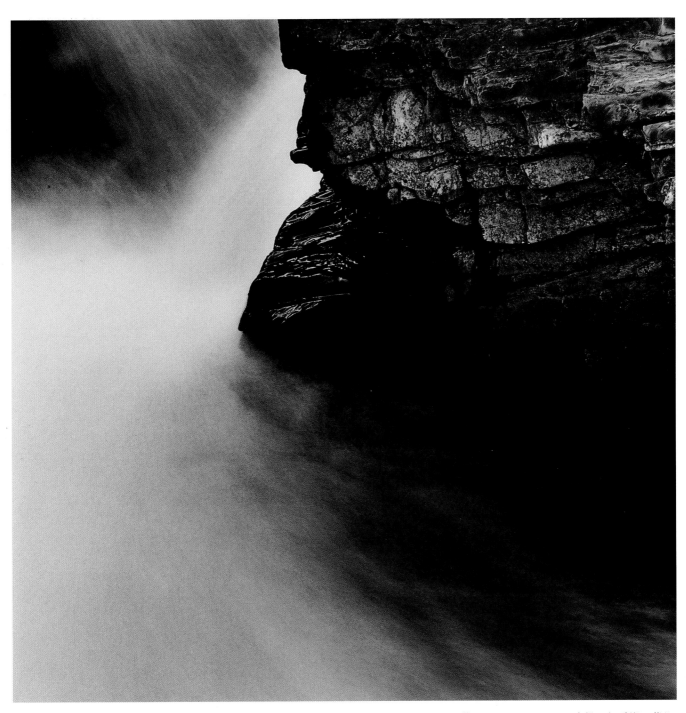

Dream Valley, Nantou, 1993　南投・仁愛鄉・夢谷

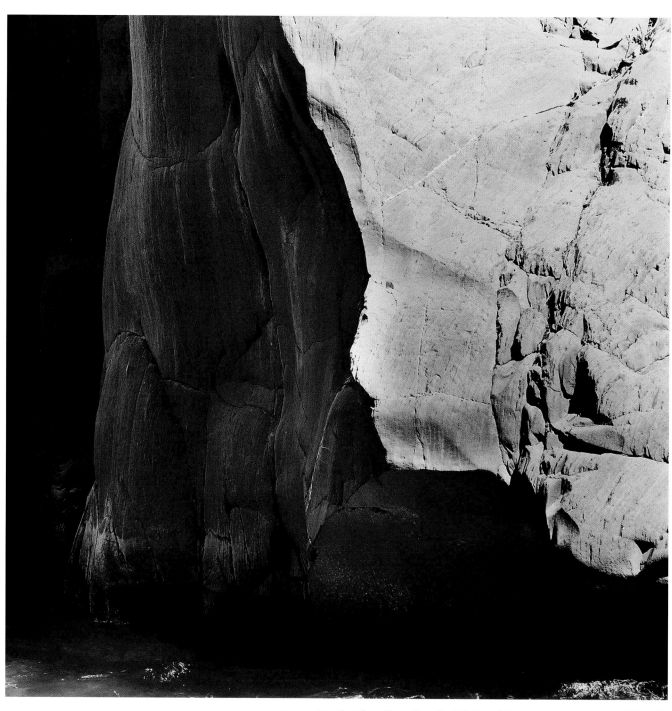

Forest Trail, Chingliou, Provincial Road No. 7, 1997　台7甲・清流林道

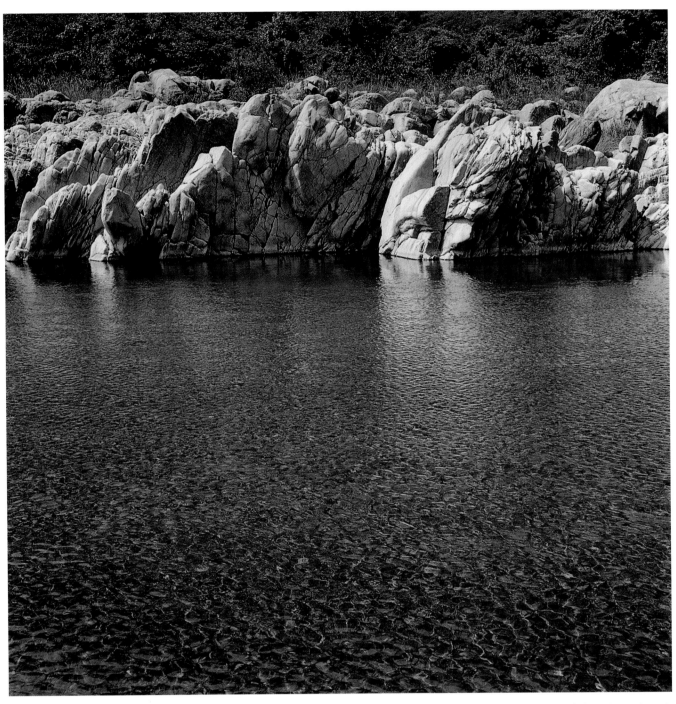

Dajia Stream, Liyang, the Central Cross-Island Highway, 1998　中橫・麗陽・大甲溪

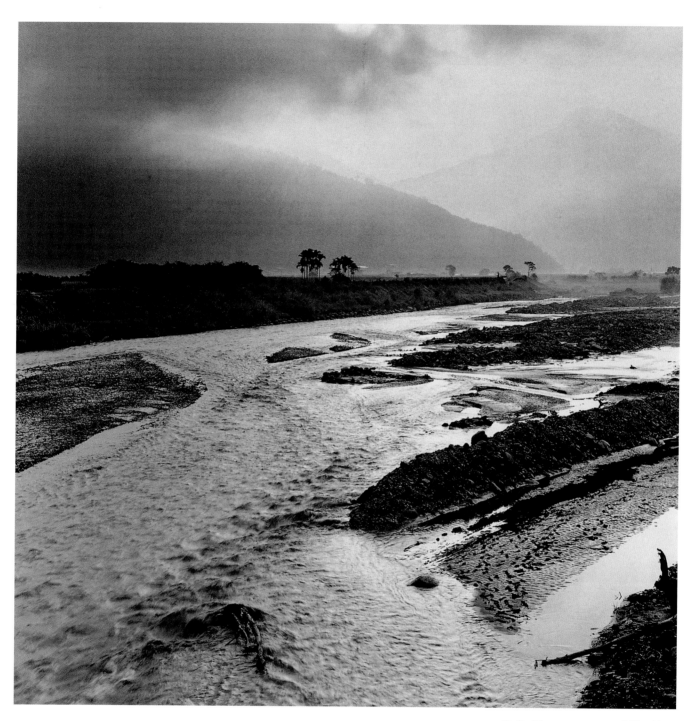

Puli, Nantou, 1994　南投・埔里

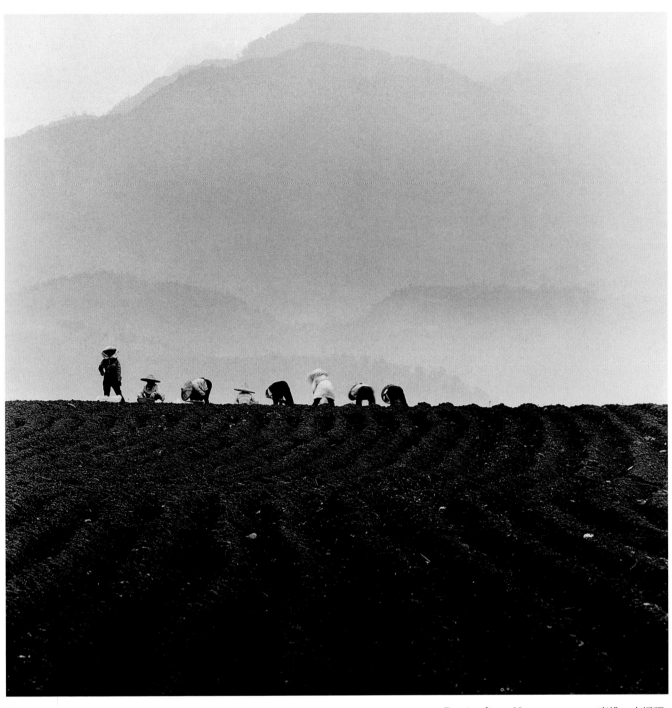

Dapingding, Nantou, 1995　南投・大坪頂

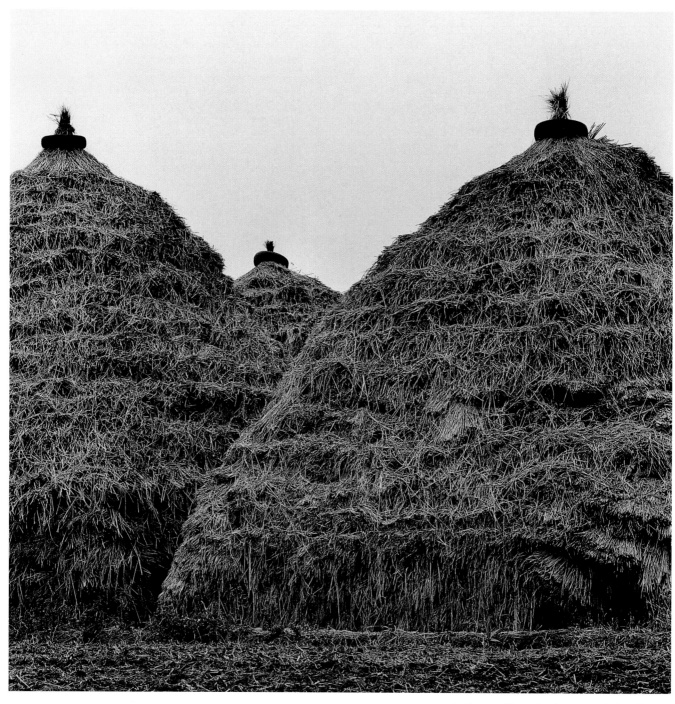

Fenyuan Village, Changhua, 1996　彰化・芬園鄉

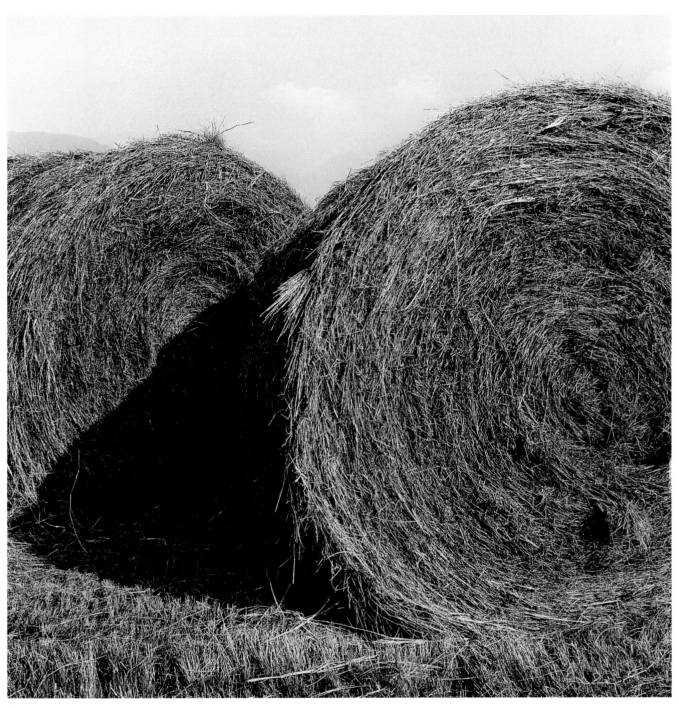

Dapingding, Nantou, 1996　南投‧大坪頂

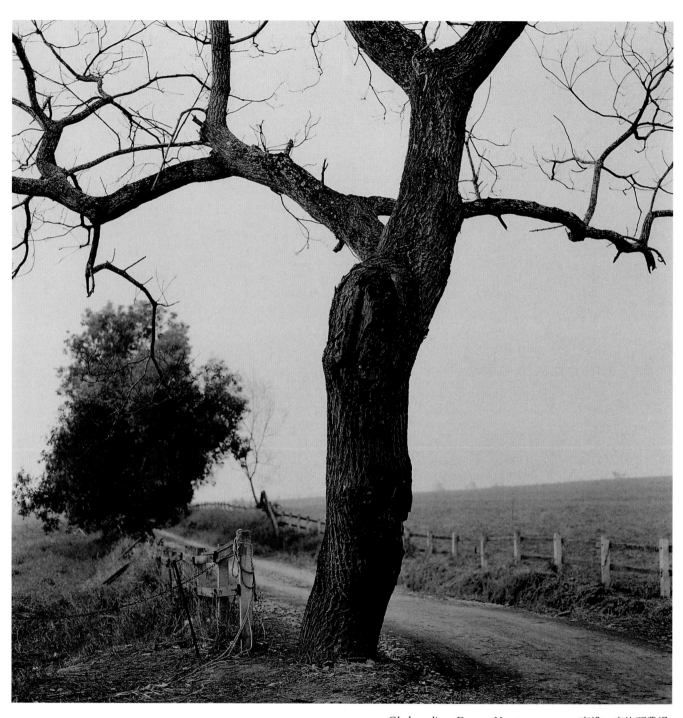

Chrkanding Farm, Nantou, 1997　南投・赤坎頂農場

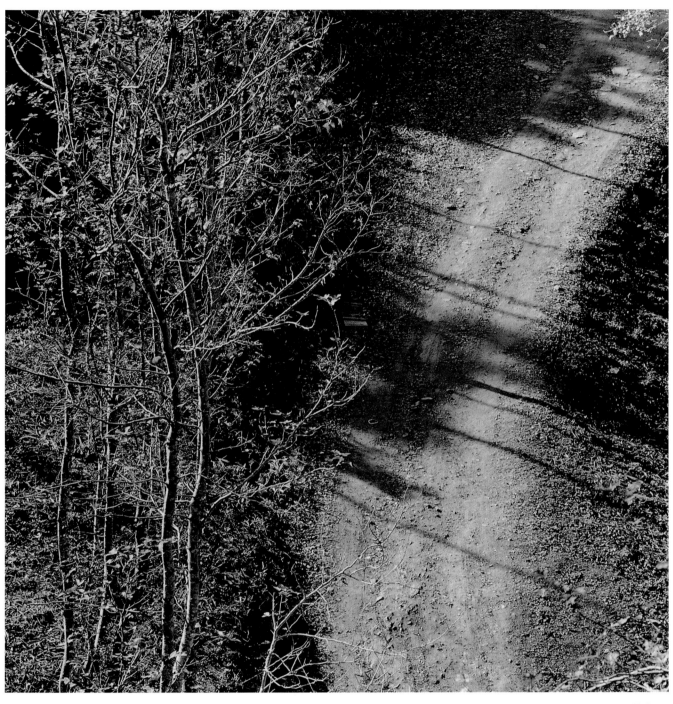

Fengshulin Farm, Nantou, 1997　南投・仁愛鄉・楓樹林農場

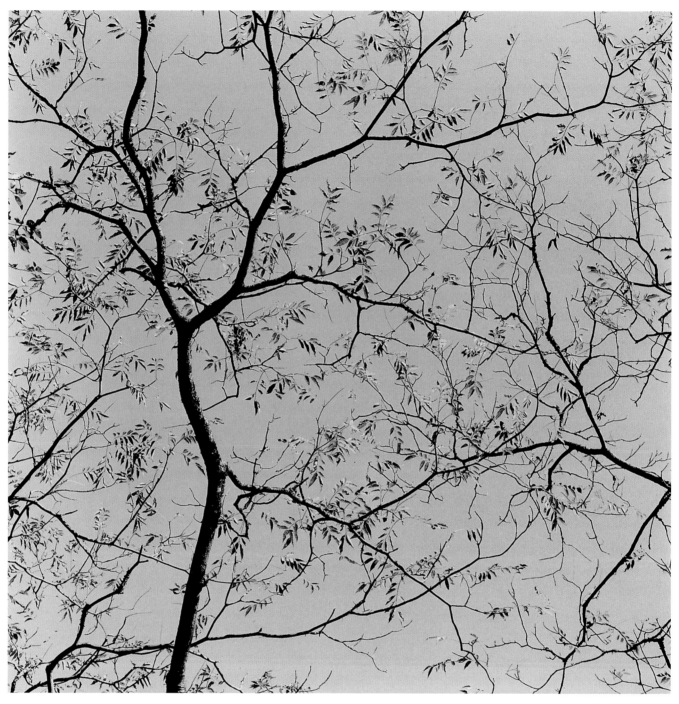

Forest Trail, Mt. Dashiue, Taichung, 1998　台中・大雪山林道

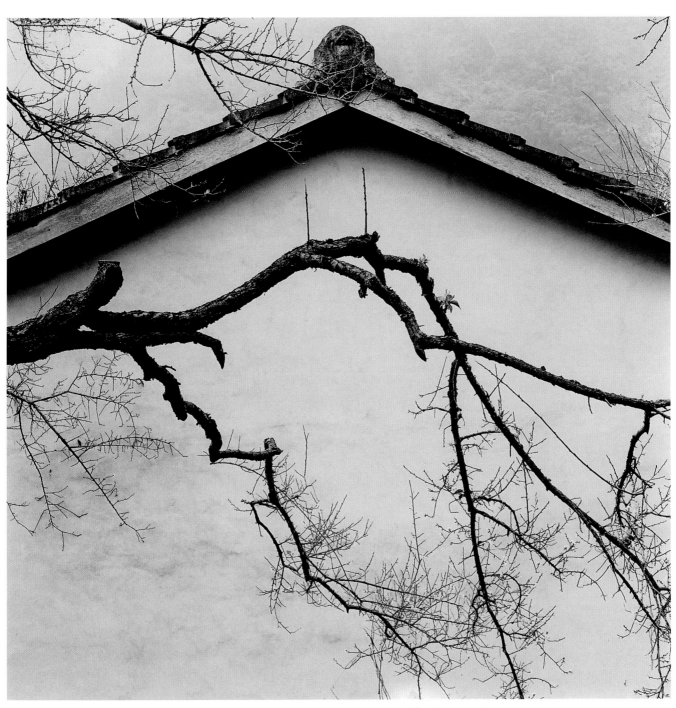

Mt. Fenggueidou, Nantou, 1999　南投・風櫃斗山

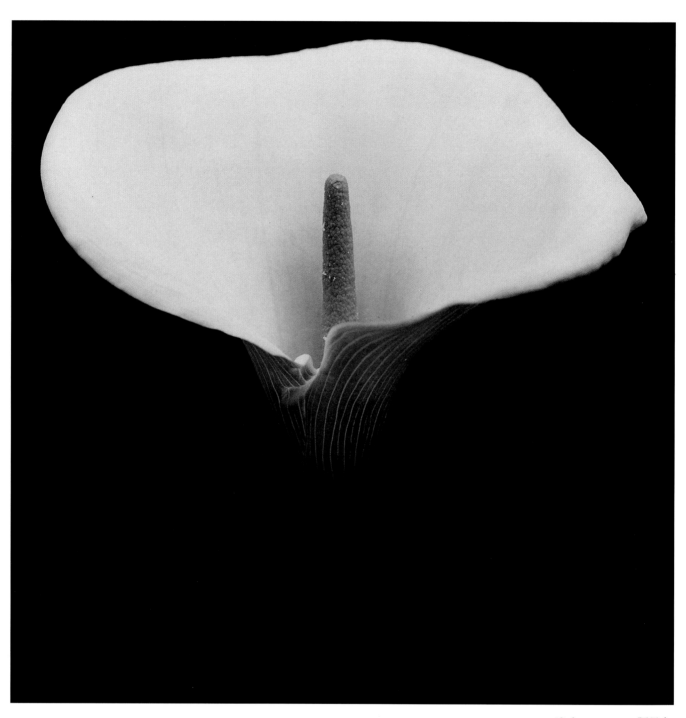

Alishan, 1997　阿里山

張 志 輝 年 表

1965　10月14日生於台灣省彰化市的農村——快官莊
1973　就讀彰化市中山國小。喜歡塗鴉,玩自製的滑翔機
1979　就讀彰化市陽明國中。喜歡素描、水彩、組裝模型飛機
1981　與好友哲彰共同完成一枚實驗火箭,但發射失敗,沒有升空
1982　就讀省立彰化高工,機械工程科
　　　同年加入校內攝影社,首次接觸攝影及黑白暗房
1985　二專聯考落榜,轉入補習班補習重考
1986　就讀勤益工專機械工程科製造組
　　　同年入校內攝影社,依舊喜歡素描、攝影、黑白暗房
1988　4月1日愚人節入伍當兵,於金門前線服役
1990　2月15日退伍,返回台灣彰化市。
　　　3月至5月在彰化市一家照相館擔任攝影師,因工作單調無趣而離職
1990　7月到台北〈圖騰攝影教室〉阮義忠先生的高級黑白暗房班進修研習
　　　開始認真拍照,沖洗放大,題材以大自然為主軸
1990　12月任職彰化市理光公司技術部
1991　2月於彰化市創辦阿爾攝影藝廊,後因財務問題而結束運作,前後約半年,辦過四檔展覽
1995　5月任職台北〈攝影家專業沖印公司〉主任
1996　2月於台北〈圖騰攝影教室〉擔任「黑白風景／暗房進階班」課程講師
1996　12月於台中市成立〈亞當斯專業沖印／攝影教室〉
1997　6月和胡海珍結婚
1999　2月兒子張易晟出生

著 作

1997　8月〈靈‧靜山水——張志輝攝影集〉　攝影家出版社

個 展

1999.3.20-3.28　靈‧靜山水 (1993-1998)——張志輝攝影展
　　　　　　　　（台北爵士攝影藝廊,28幅作品）
1999.4.1-4.30　靈‧靜山水 (1993-1998)——張志輝攝影展
　　　　　　　　（台中飛狼山野教育中心,20幅作品）
1999.7.10-7.23　靈‧靜山水 (1993-1999)——張志輝攝影展
　　　　　　　　（台北美國文化中心,45幅作品）

CHANG CHIH-HUEI HISTORY

1965 October 14, born in countryside, Changhua City, Taiwan

1973 Chungshan Primary School, Changhua. Enjoys drawing, making handmade gliders

1979 Yangming Junior High School, Changhua. Enjoys sketching, watercolor, assembling model airplanes

1981 Makes experimental rocket with good friend, Che-chang, but launch attempt fails

1982 Changhua Technical High School, Mechanical Engineering Department; joins school's photography club, encounters photography and black and white darkroom for first time

1985 Fails to test into junior college; enters cram school to prepare re-test

1986 Enters mechanical engineering department, manufacturing section of the Chin Yi Vocational College; joins the school photography club, continues pursuit of sketching, photography, black and white darkroom techniques

1988 Enters military on April Fool's Day; stationed on the front line at Kinmen

1990 Discharged from military on Feb. 15, returns to Changhua City. Works as photographer at a Changhua photography shop from March through May, but quits for lack of challenge

1990 Arrives in Taipei in July to study with Mr. Ruan Yi-chung at his advanced black and white darkroom, Totem Photo School; begins serious photography, developing and enlargement. Subject matter centers largely on nature themes.

1990 December. Employed in the technical department of the Ricoh corporation, Changhua City.

1991 Returns in December to Taipei's Totem Photo School to study zoom system theory under Mr. Chiang Tsai-rong

1994 February. Founds Arles Photography Gallery in Changhua. Forced to close after six months and four exhibitions due to financial issues.

1995 May. Employed as director of Photographers Lab, Taipei

1996 February. Instructor in black and white landscape, intermediate darkroom techniques, at Totem Photo School, Taipei

1996 December. Establishes Adams photo Lab/School, Taichung

1997 June. Marries Miss Hu Hai-chen

1999 February. First son, Chang Yi-cheng, is born.

WORKS CHANG CHIH-HUEI HISTORY

1997 Aug. *Spirit V Tranquil Landscapes—Collection of Photography by Chang Chih-huei* is published (Photographers Lab)

SOLO EXHIBITIONS

Mar. 20-28, 1999 *Spirit · Tranquil Landscapes* (1993-1998)—Chang Chih-huei Photography Exhibition Jazz Photography Gallery, Taipei (28 works)

Apr. 1-30, 1999 *Spirit · Tranquil Landscapes* (1993-1998)—Chang Chih-huei Photography Exhibition Feilan Shanye Educational Center, Taichung (20 works)

Jul. 10-23, 1999 *Spirit · Tranquil Landscapes* (1993-1998)—Chang Chih-huei Photography Exhibition American Cultural Center, Taipei (45 works)

靈 ・ 靜　山水

作　　者：張志輝
出 版 者：攝影家出版社
發 行 人：袁瑤瑤
社　　長：阮義忠
製版印刷：沈氏藝術印刷股份有限公司
發 行 者：攝影家出版社
地　　址：台北市重慶南路一段 61 號 10 樓 1015 室
電　　話：(02) 23123320, 23890866
傳　　真：(02) 23317659
總 經 銷：吳氏圖書有限公司 (台北縣中和市中正路 788-1 號五樓 TEL : 02-32340036)
初　　版：中華民國八十八年十月
定　　價：500 元
郵政劃撥：帳號 15815753 ／戶名 : 攝影家雜誌社
行政院新聞局登記證局版臺業字第 4616 號

封面設計／內頁編排 : 馮君藍

PHOTOGRAPHERS PUBLICATIONS
BOX 39-1265,TAIPEI POST OFFICE
TAIWAN,R.O.C.
TEL: (02)23123320,FAX: (02)23317659

PUBLISHER／EDITOR
JUAN I-JONG
OFFICE MANAGER
NATHALIE JUAN